love
MADE VISIBLE

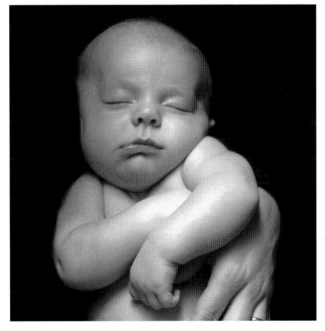

PAUL BRENNER, MD, PhD

PHOTOGRAPHY BY SUSAN WINGATE

COUNCIL OAK BOOKS

SAN FRANCISCO & TULSA

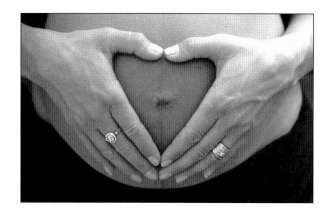

Council Oak Books, LLC
counciloakbooks.com

ISBN-10: 1-57178-183-8
ISBN-13: 978-1-57178-183-3

Library of Congress cataloging-in-publication data

Brenner, Paul, 1933-
 Love made visible / Paul Brenner ; photography by Susan Wingate.—
1st ed.
 p. cm.
 ISBN 1-57178-183-8
1. Portrait photography. 2. Pregnant women—Portraits.
3. Photography of families. I. Wingate, Susan. II. Title.
 TR681.P67B74 2005
 779'.24'092--dc22

 2005014775

Printed in Canada

introduction

FORTY-FIVE YEARS AGO, as a fourth year medical student, I sat alone with a woman in labor. It was her fifth pregnancy, but a first for me. I had no idea what to expect.

Suddenly (or so it seemed to me), she looked at me and said, "I'm ready."

I shouted for a nurse or obstetrical resident to help, but no one responded. Panicked, I rushed her to the delivery room, helped her on the table and turned to wash my hands.

"You better hurry up," she said as I was scrubbing up. "Are you ready?"

"Sure," I said hesitantly, turning back to her.

At that moment, the head crowned, and I caught my breath in wonder. As I reached to catch the baby, the whole room seemed to burst into a brilliant gold.

SO BEGAN MY COMMITMENT to be an obstetrician/gynecologist and a part of this miracle of birthing.

Being a male obstetrician has had a profound effect on my life. Simply put, conception, pregnancy, labor, and delivery always seemed mystical, magical. During every delivery, I would whisper to myself, "What a miracle!" To know that two microscopic cells can fuse to become one and, within nine months, become this incredible gift of life, boggled my mind. The miracle, with all its perfect order, shaped my personal spirituality.

I remain in awe of the process by which the shared intention of a man and woman makes love visible in the form of a newborn child.

Paul Brenner, MD, PhD

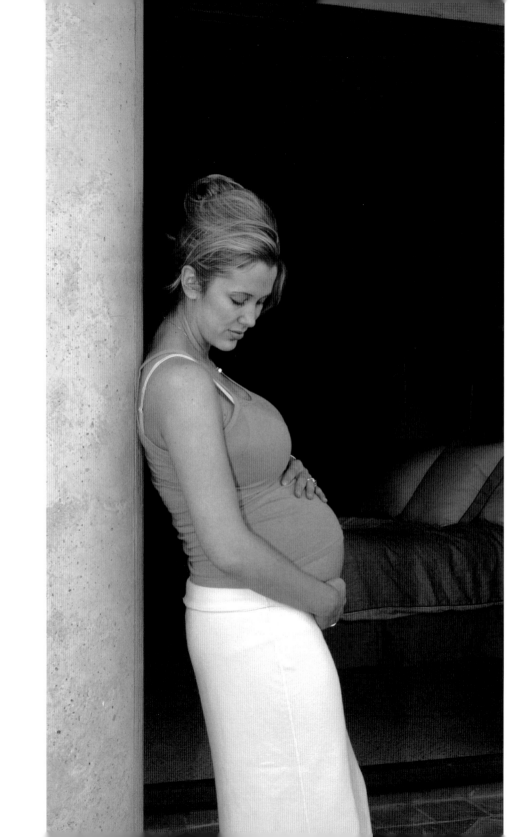

One thought gives birth to the ETERNAL THREAD OF LIFE.

create life

The initial thought to conceive, **TO CREATE LIFE**,
is in itself an act of both insemination and fertilization.

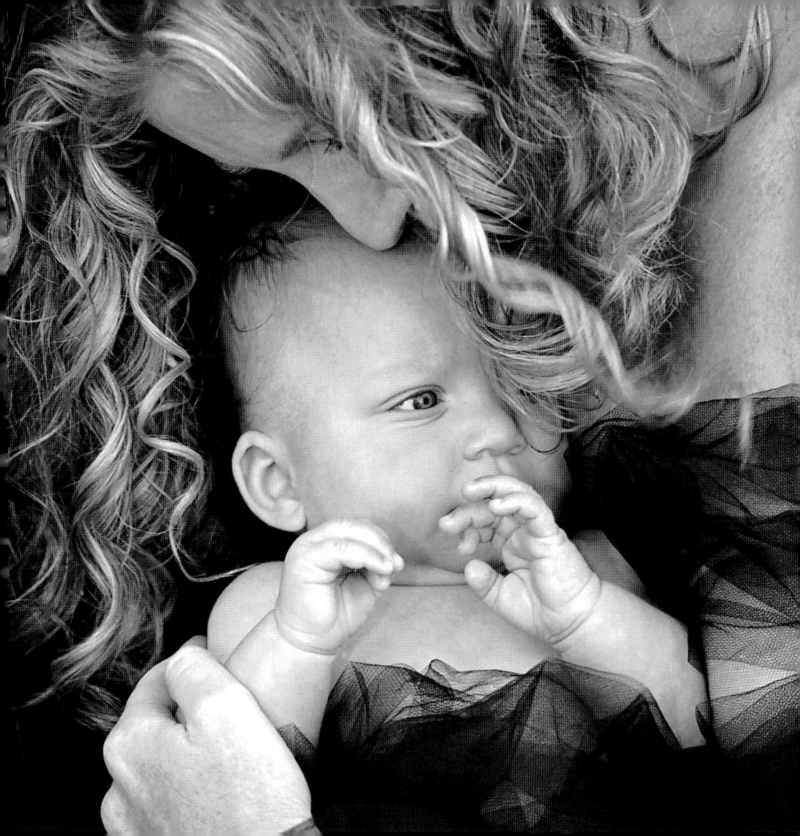

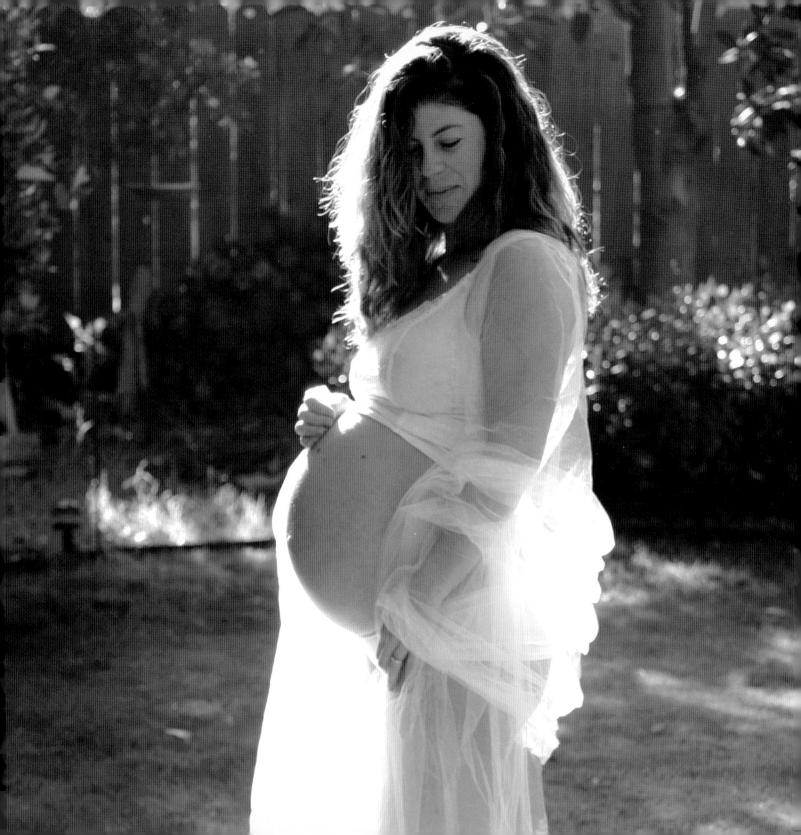

IN THE BEGINNING THOUGHT EXISTED.
The initial thought to sustain humanity was love.
That thought of love continues still and
FOREVER INTO ETERNITY.

ALL LIFE'S CREATIONS INVOLVE THE
TRANSFORMATION OF A SINGULAR
FORMLESS THOUGHT OF LOVE
into a multitude of manifest loves. It is
through such a transformational process
that humankind infinitely evolves, infinitely
aspires, and so, once again, returns to
absolute love.

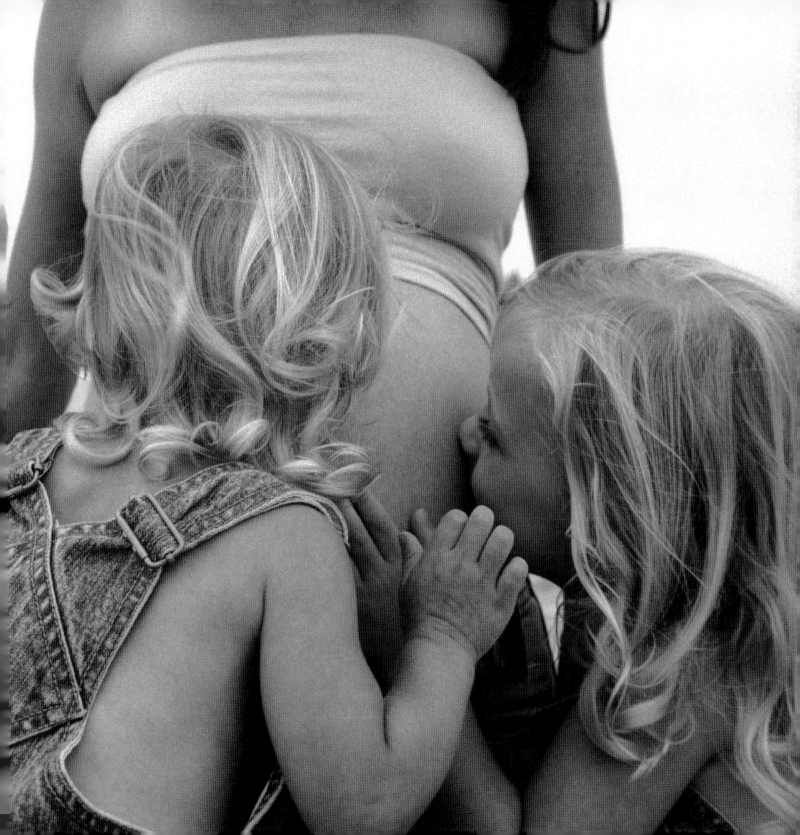

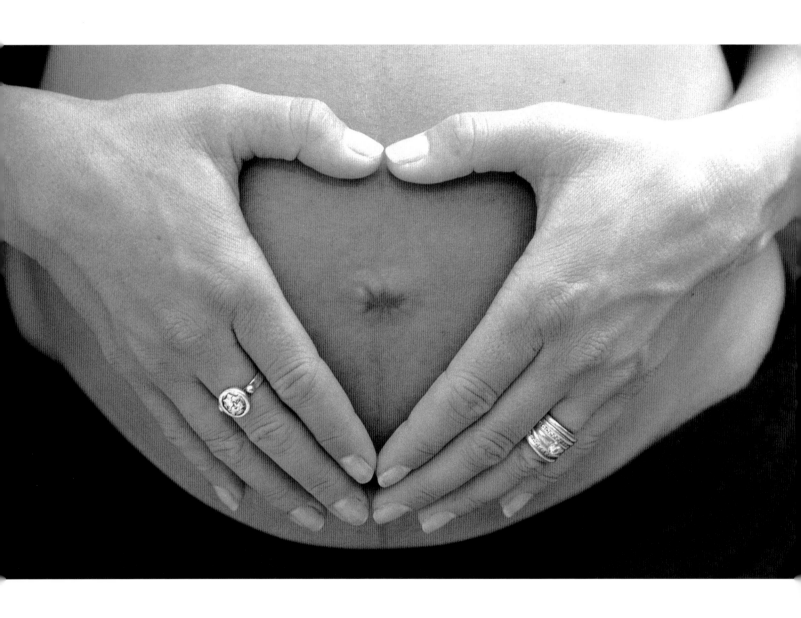

love

The only mystery worth conceiving, worth sharing is LOVE.

Love is the indefinable
RESONATING ENERGY OF LIFE.

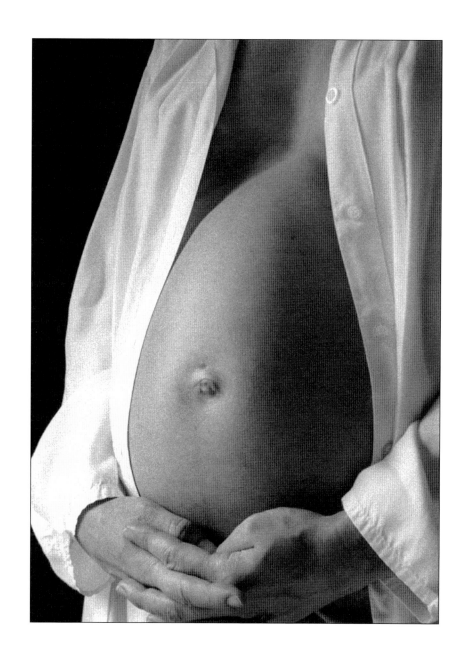

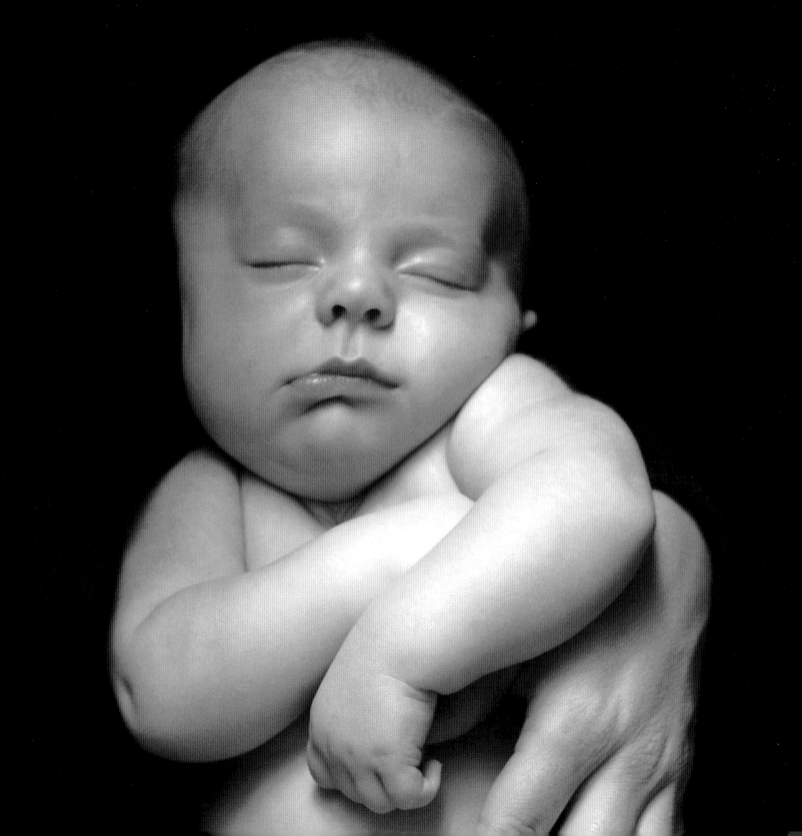

The newborn is LOVE MADE VISIBLE.

The newborn is conceived in that moment appropriately referred to as "making love"—a moment when FORMLESS LOVE IS TRANSFORMED INTO MANIFEST LOVE.

manifest love

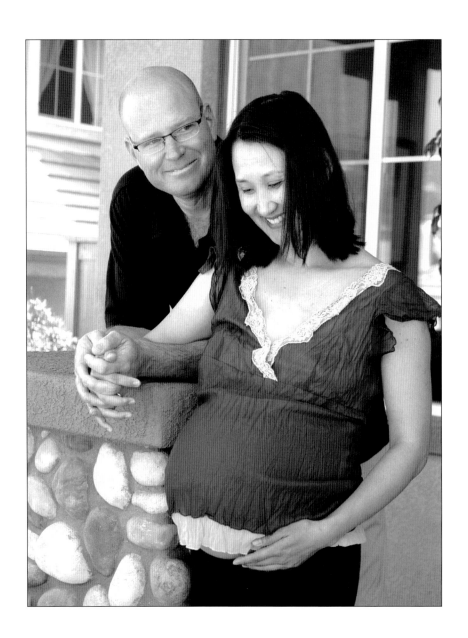

LOVE IS THE BOND, the translucent thread that runs through all teachings about creation and life, linking the myriad projections, sensations, and emotions, which fill the time span from the first intention to conceive a child until its birth. Once the perfection of this thread is recognized and followed, it becomes strong enough to sustain the bond of husband and wife, mother and father, and that jewel in the necklace, the newborn.

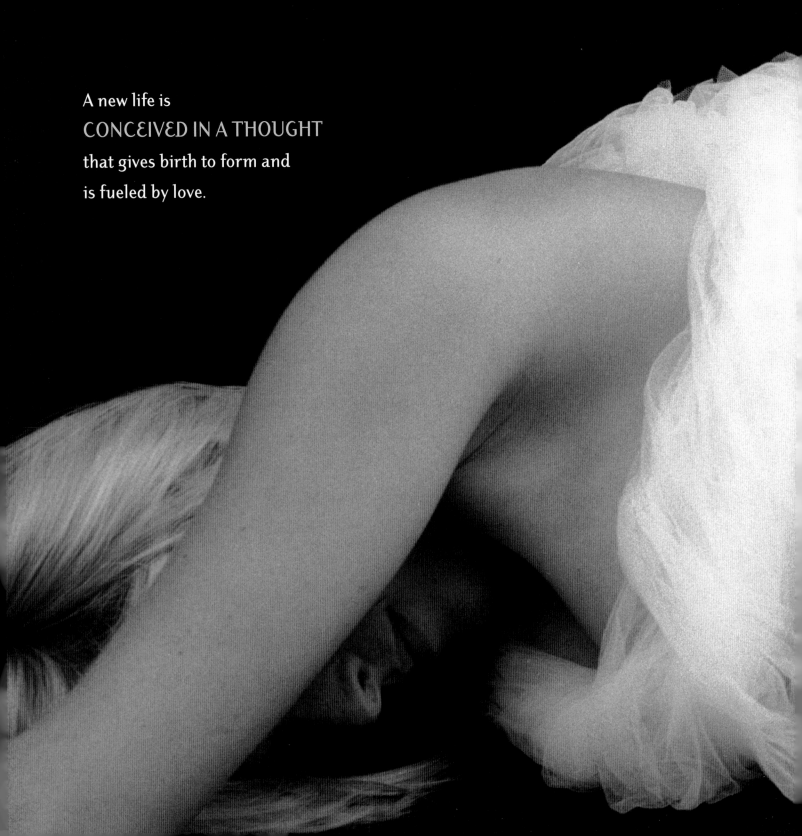

A new life is
CONCEIVED IN A THOUGHT
that gives birth to form and
is fueled by love.

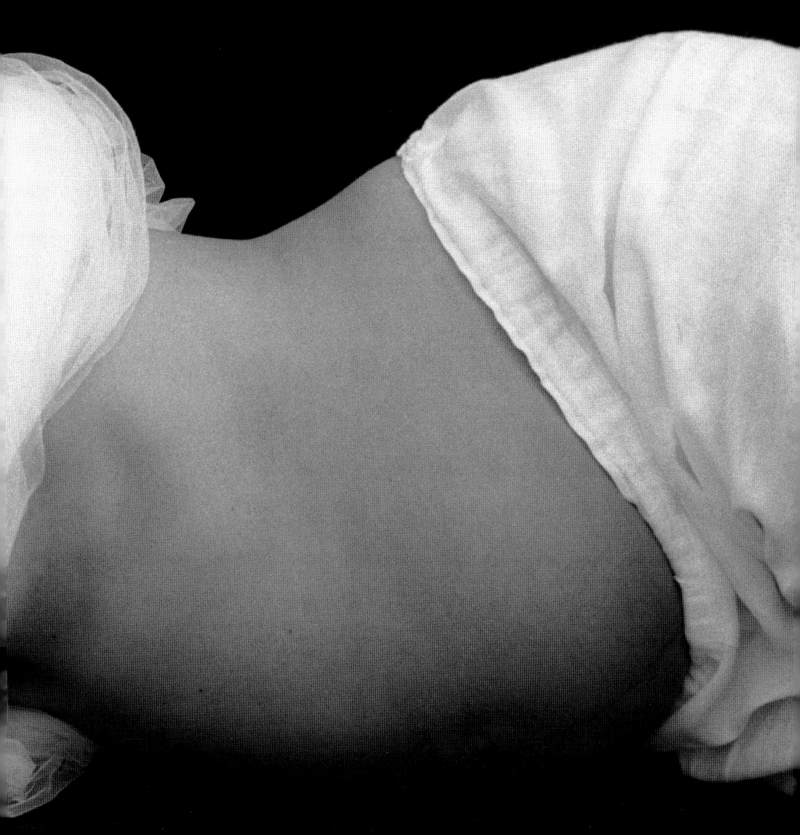

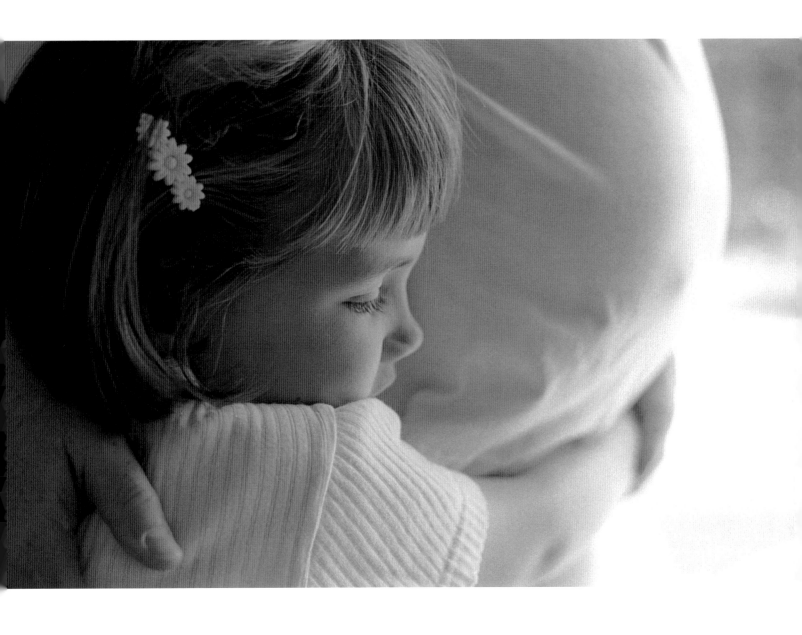

Life begins before conception, is reshaped by birth and is NURTURED THROUGH PARENTING.

creation

Creation is the metaphor for resolving life's paradox
of duality (male and female) and yet, prophetically,
DUALITY IS THE PARENT OF CREATION.

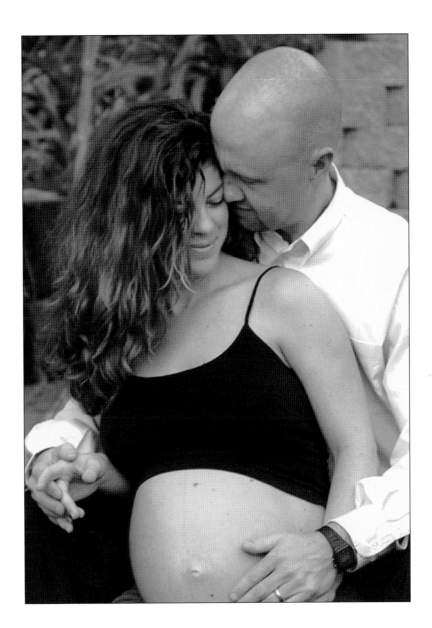

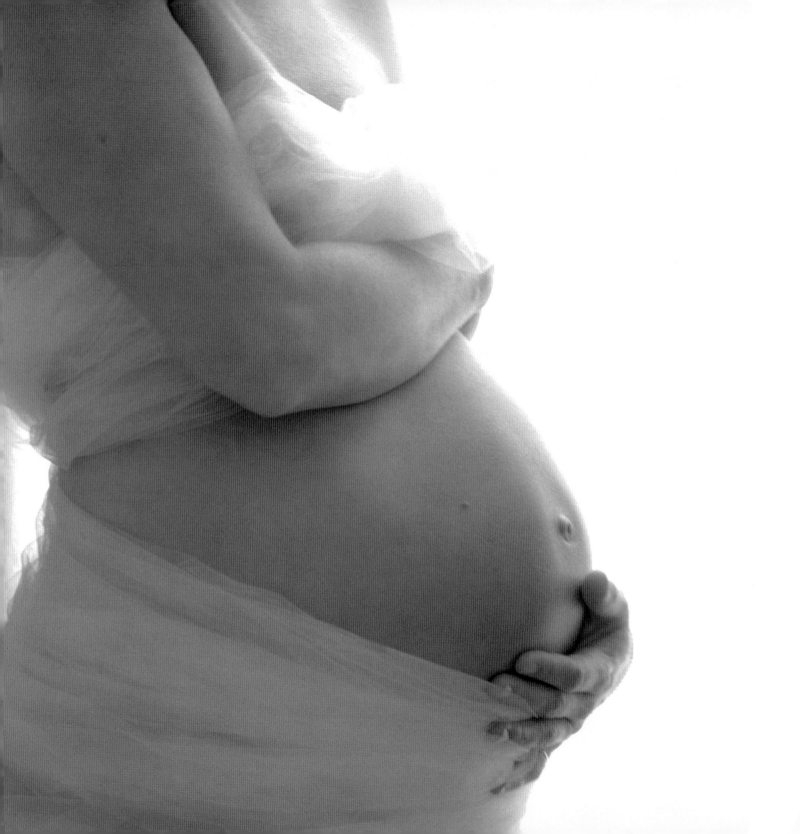

love

Love is the highest form of alchemy,

THE NEWBORN ITS HIGHEST CREATION.

Conception, pregnancy, and childbirth
are, respectively, metaphors for
LOVE, LIFE AND CREATION.

Our desire to HONOR LIFE WITH
LIFE AND TO TRANSFORM LOVE
into form prompts us to have children –
our gift to life – life's gift to us.

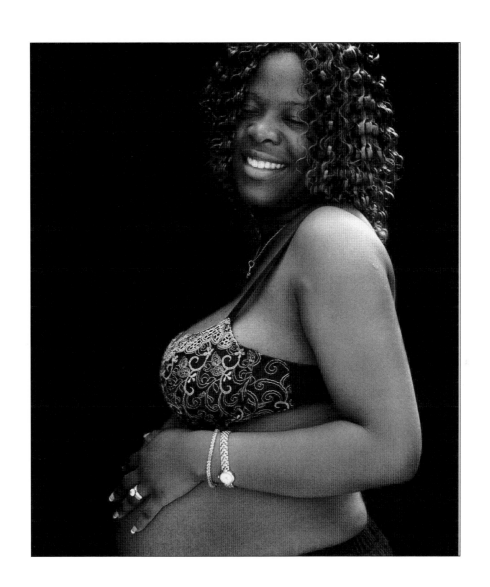

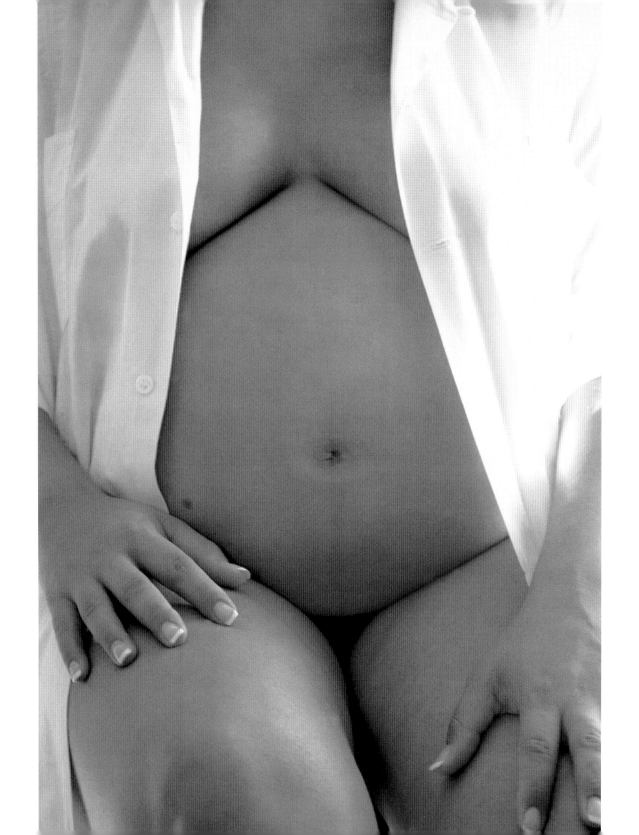

So life occurs not only in the moment when the sperm penetrates the egg, but when the ripe ENERGY OF PARENTAL LOVE fuses with the unblemished ENERGY OF THE YET UNBORN.

born free

The IMMACULATE CONCEPTION is a
being who is born free from parental projections.

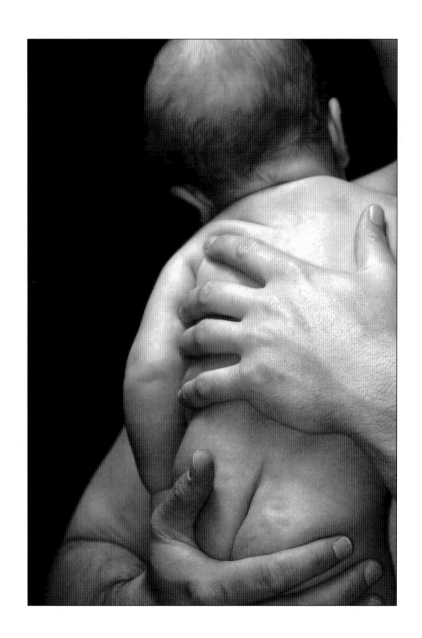

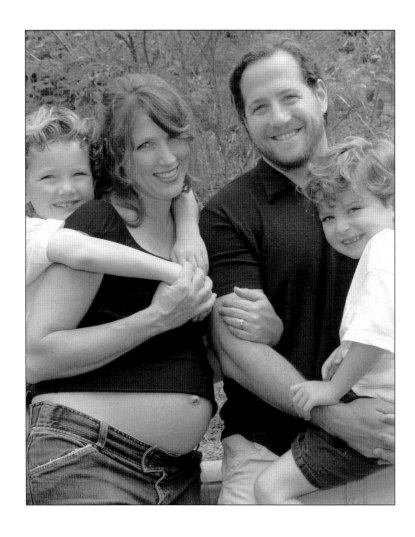

PREGNANCY ENCOMPASSES all the drama of a complete lifetime and offers a test to the marriage, a test that can either temper a relationship between man and woman or fracture it.

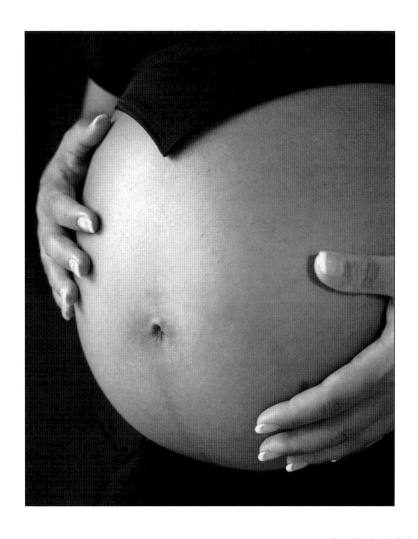

The experience of pregnancy is life's teacher of PATIENCE, TOLERANCE, TRUST, AND SURRENDER.

THE COMMUNION between mother
and child is inviolate and unspeakable.

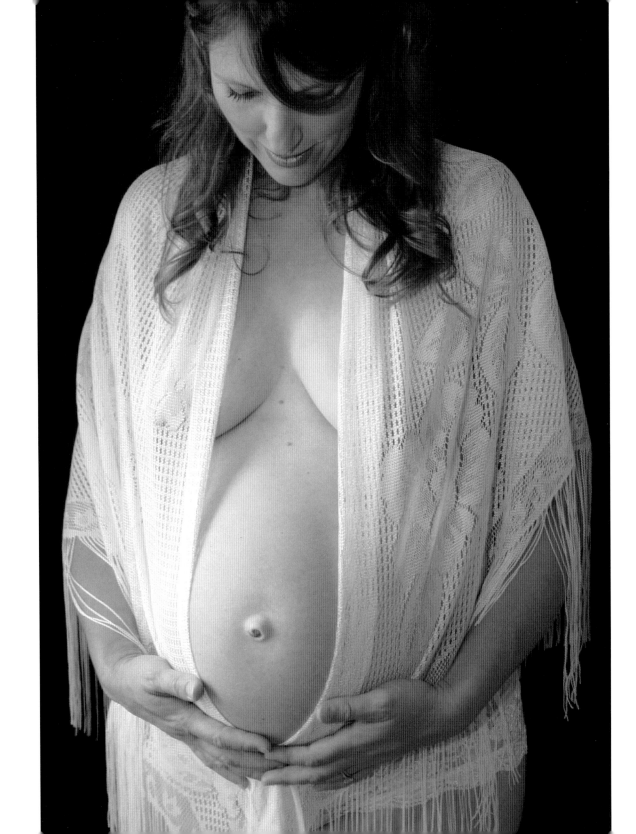

As the mother resonates with her unborn child, she is enhanced as an individual, but she also experiences the reality that TWO CAN BECOME ONE.

oneness

THE FATHER LEARNS the love of aloneness—
all oneness—and so learns to love without holding.

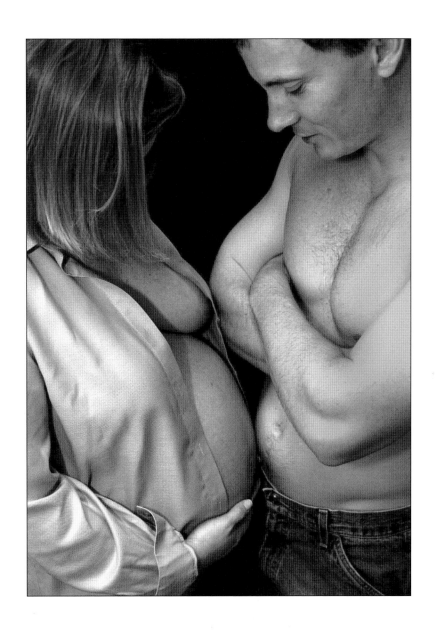

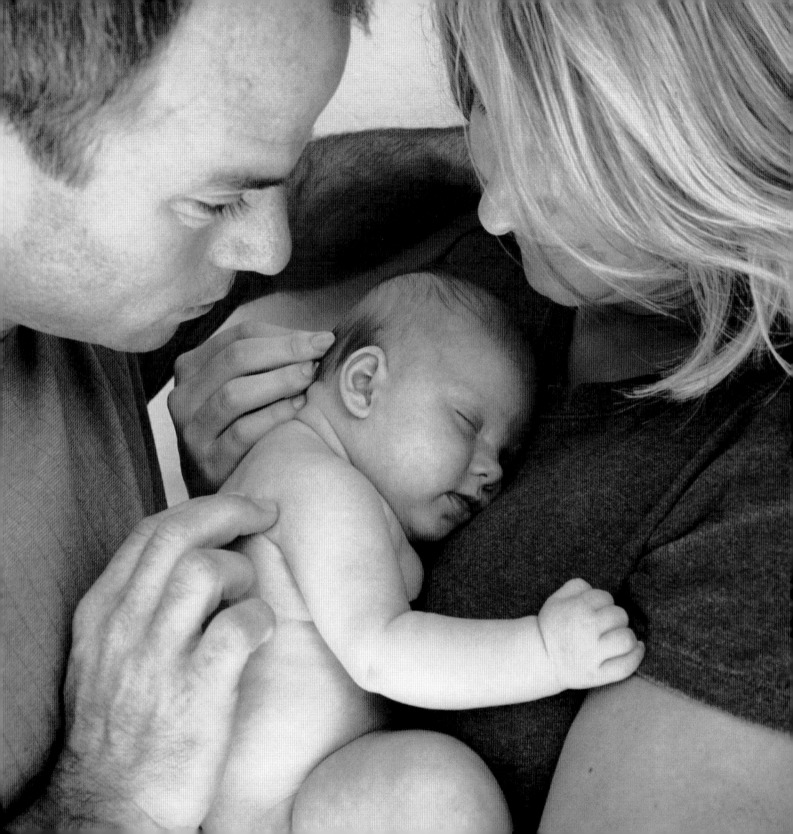

The father too labors, sacrifices and learns that TO BE APART IS TO BE A PART OF.

The mother holds the formed, CONDITIONAL LOVE; the father holds the unconditional, FORMLESS LOVE.

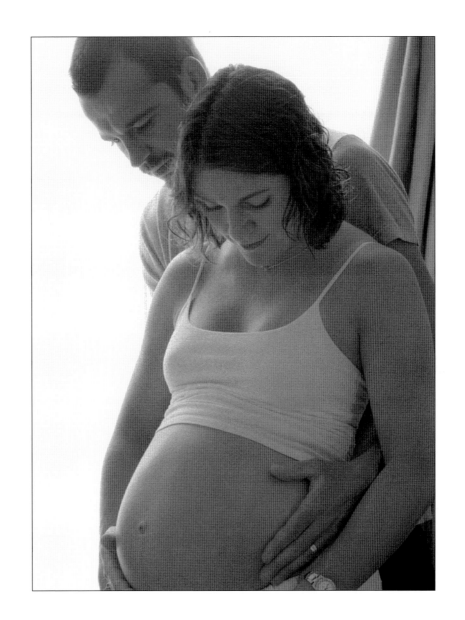

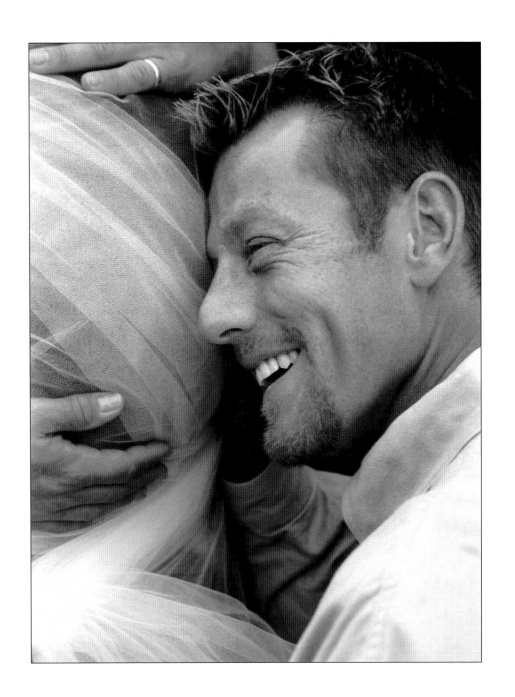

The unborn TRANSFORMS THE RELATIONSHIP
of husband and wife to the partnership of mother and father.

partnership

In the fires of motherhood and fatherhood,

THE TRINITY OF THREE BECOMES ONE.

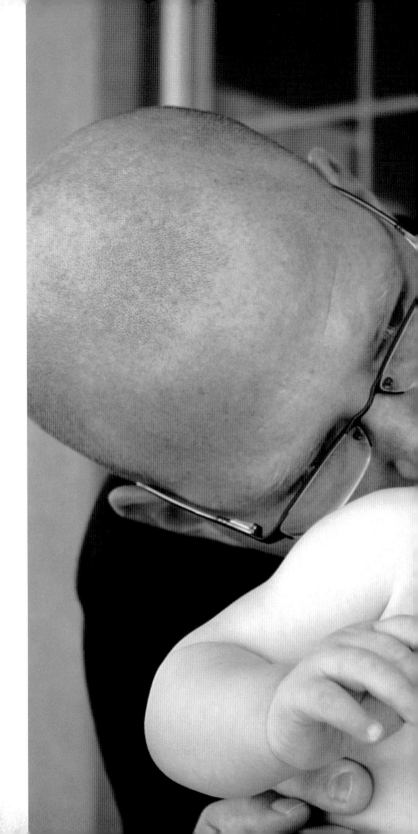

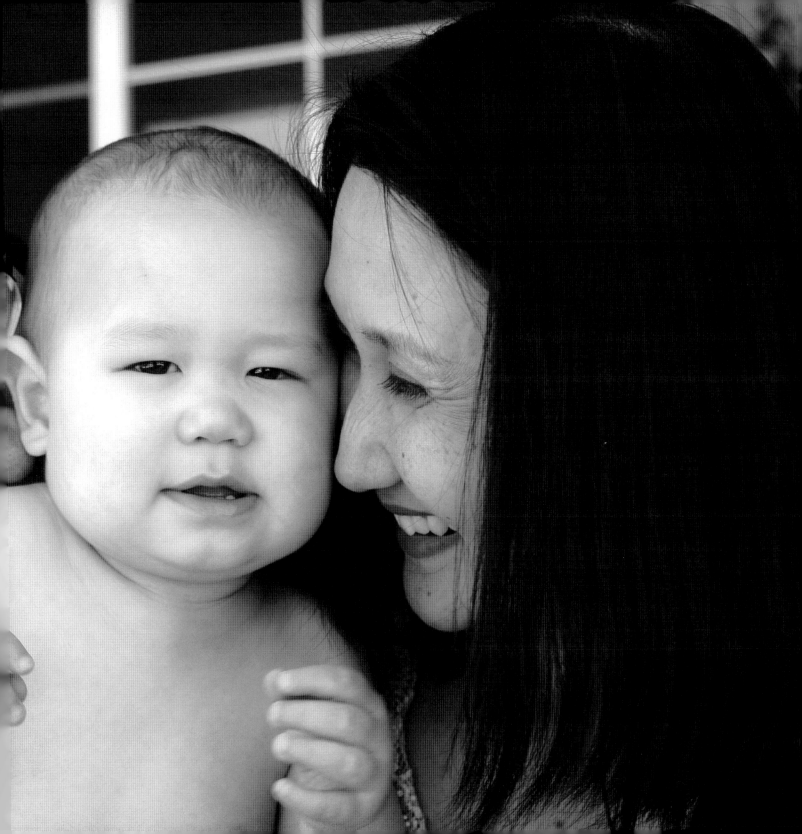

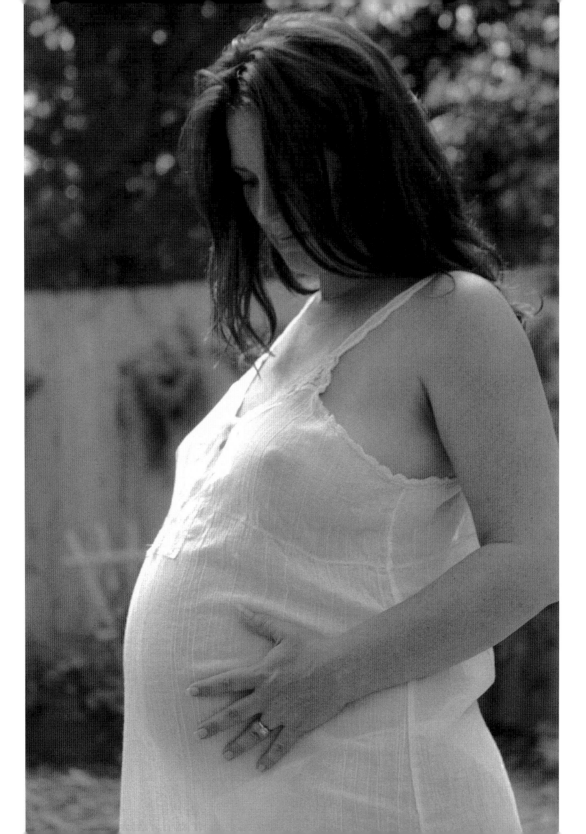

EVERY CREATIVE ACT, if it is to be
cherished, is preceded by some type of labor.

one

Labor pains herald the resurrection of
the marriage between egg and sperm—
where TWO ONCE AGAIN BECOME ONE.

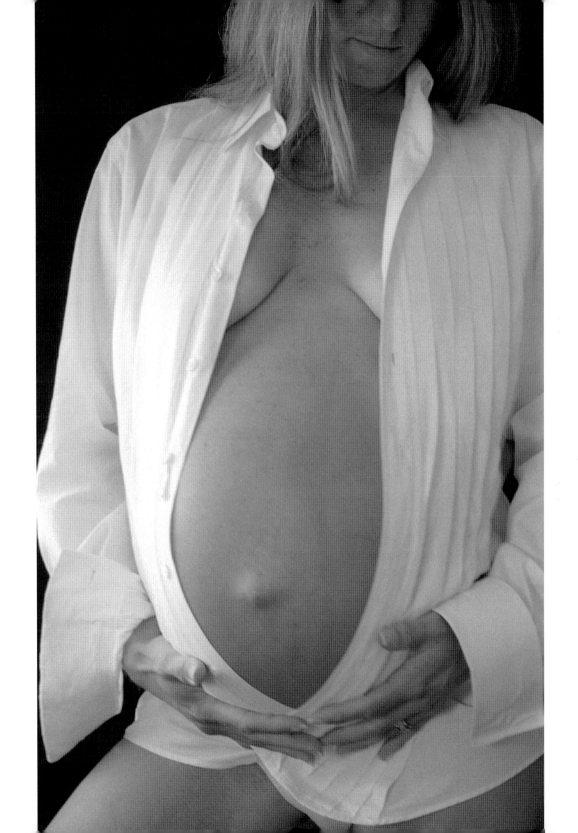

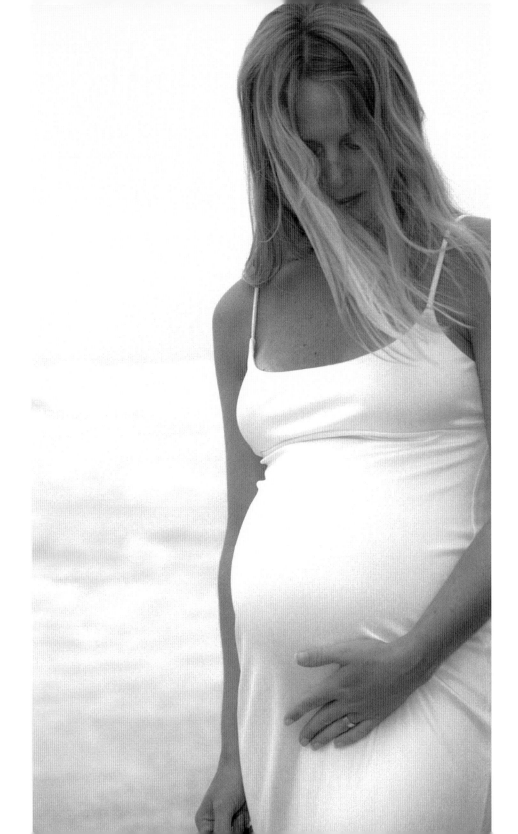

The pattern of uterine contractions and relaxation is symbolic of LIFE'S EBB AND FLOW. The contracted state gives way to the open, fluid state. Labor represents love's pain and life's renewal.

The acceptance of life's pain of labor gives birth to LIFE'S LOVE FOR LIFE.

It is not our possessiveness, but love's eternal labor, its waves of contraction and relaxation, co-creation and surrender, THAT CONNECTS US WITH OUR CHILDREN, OUR CHILDREN'S CHILDREN AND THE REST OF HUMANITY. There is never a loss, never a separation, but only an aspiring continuum to fill life's apparent void.

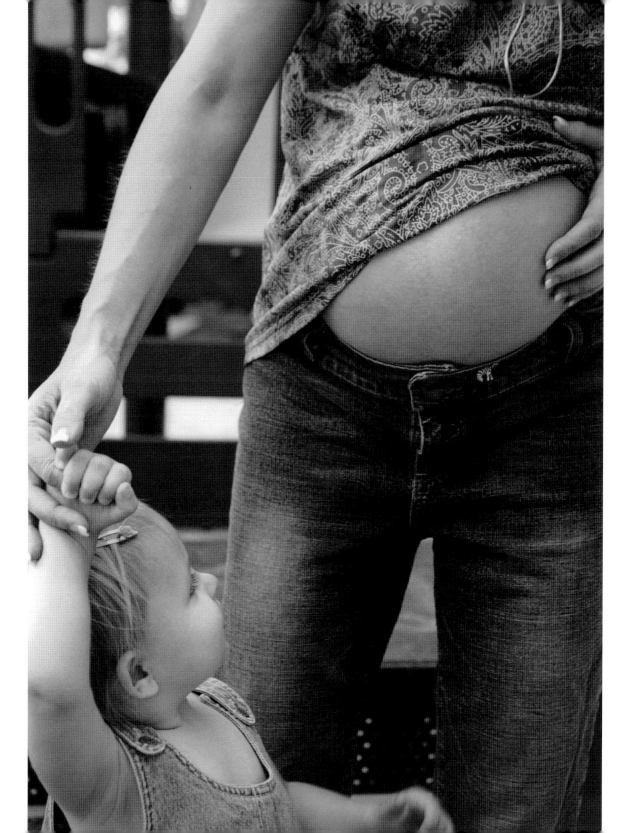

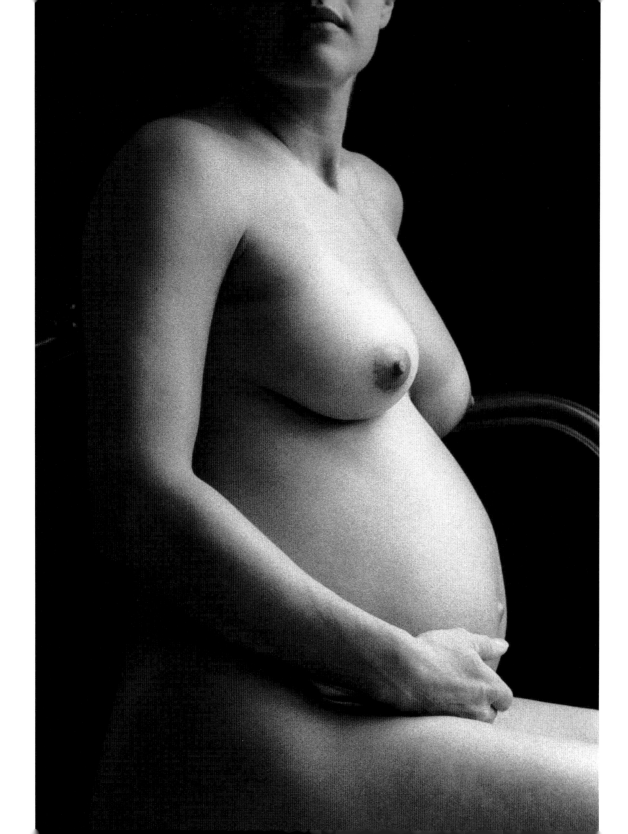

The upheavals of nine months seem more tolerable as the ECSTASY OF THE CREATION appears close at hand.

deliverance

Birth is "to be" is "to become." BIRTH IS DELIVERANCE.

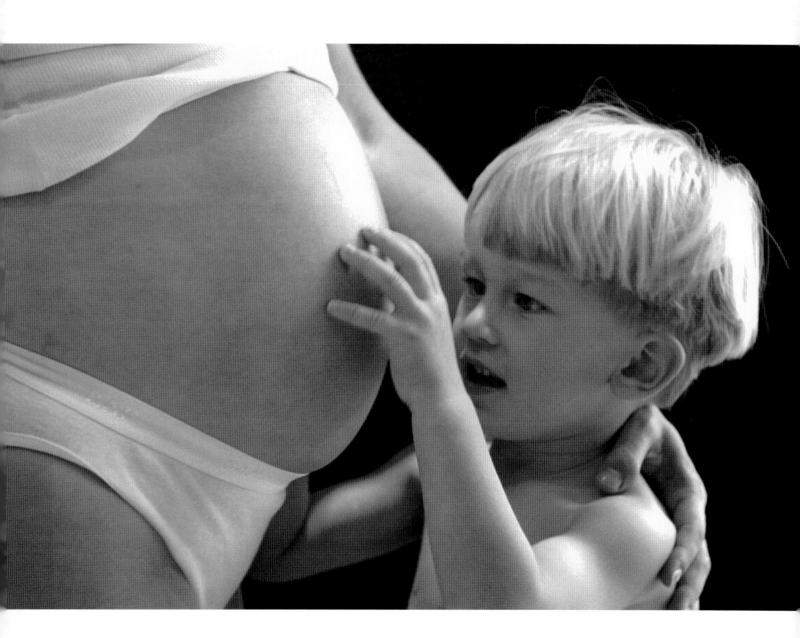

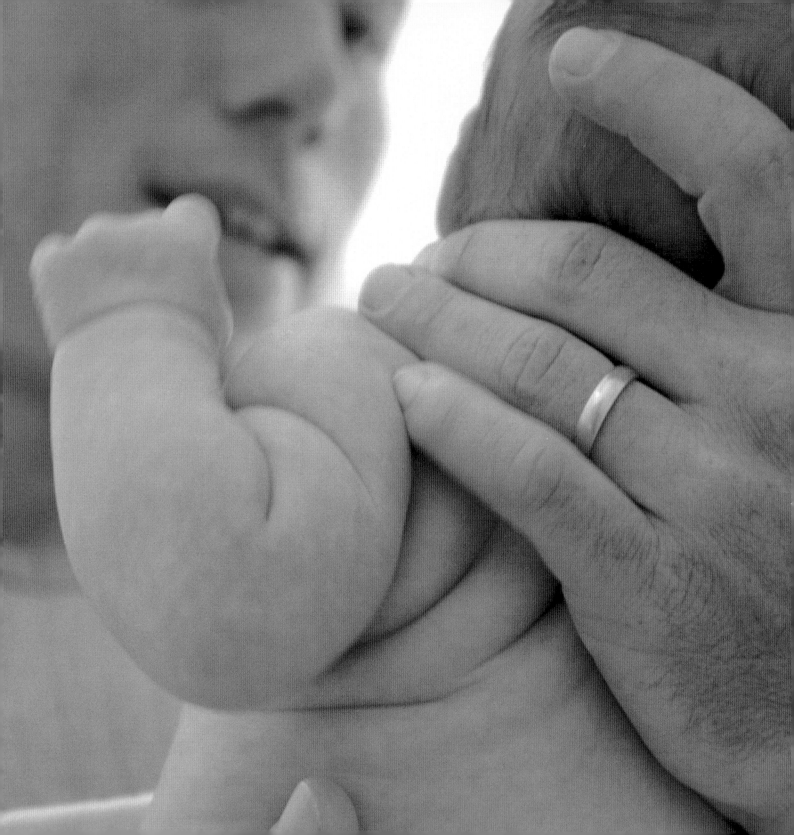

The newborn is exactly that—

A MIRACLE OF LIFE'S PERFECT CREATION.

JOY IS SYNONYMOUS with the birth of evolving life.

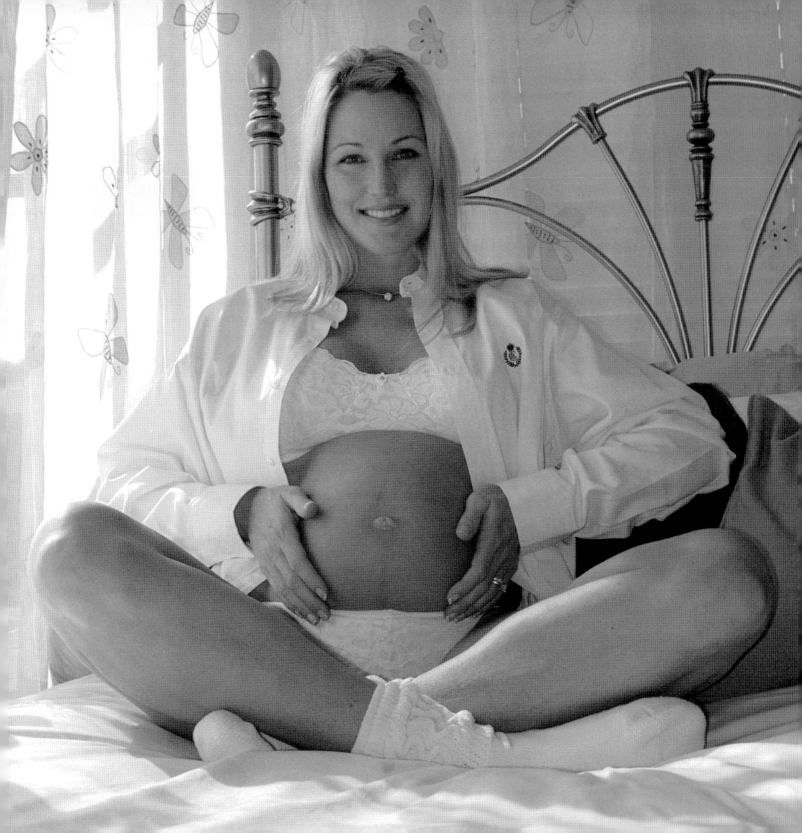

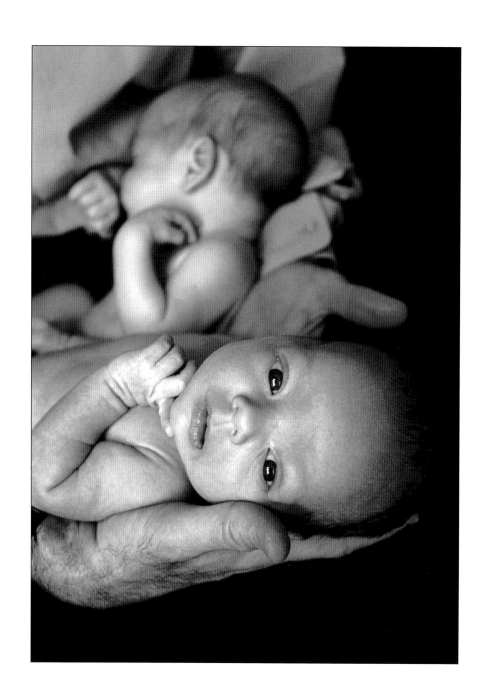

joy

In birth, joy INFUSES AND THEN UNITES the creator with the creation.

Life itself is a never-ending continuum
of repeated births into an unfolding life—
the TAPESTRY OF LIFE is patterned in love.

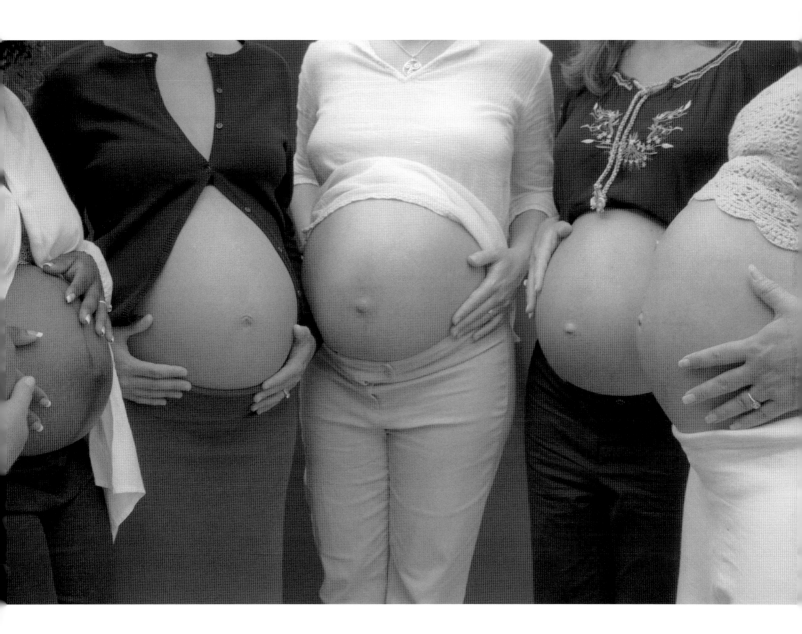

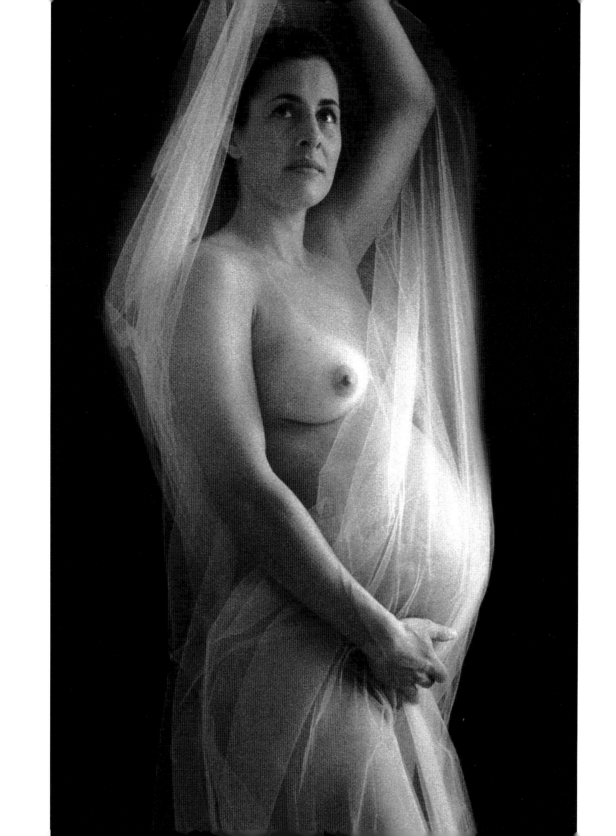

Birth is the "S" wave of the Taoist mandala that
SEPARATES DARKNESS AND LIGHT.

Birth, the final stage of pregnancy, holds within its moment
AN ENTIRE MEMORY OF ALL LIFE'S EXISTENCE.

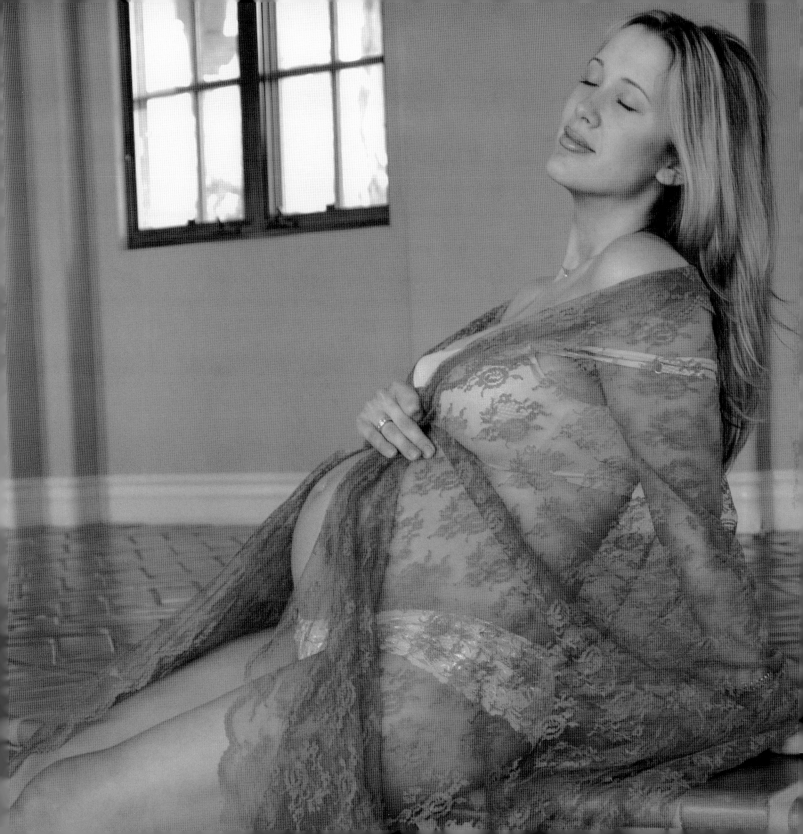

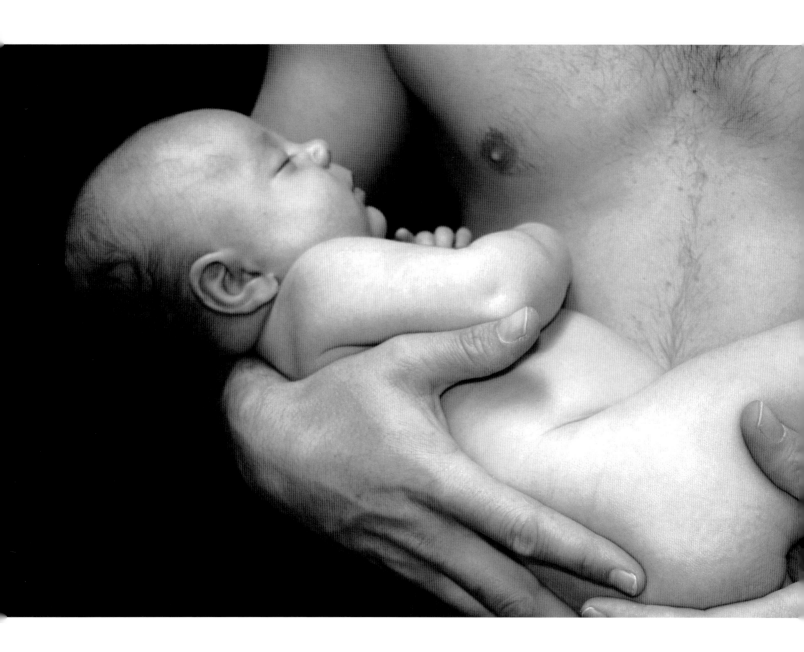

love made visible

IN THE DANCE between energy and matter, force and resistance, giving and receiving, male and female, a new creation emerges, synthesized from the multiple points of contact between disparate forms of a singular force. Finally, the formed genetic code and the formless psychic states of energy are transformed into a new being. This newborn is love made visible, the manifestation of the fusion between life and love.

To be born is to have won the greatest lottery of all—THE GIFT OF LIFE.

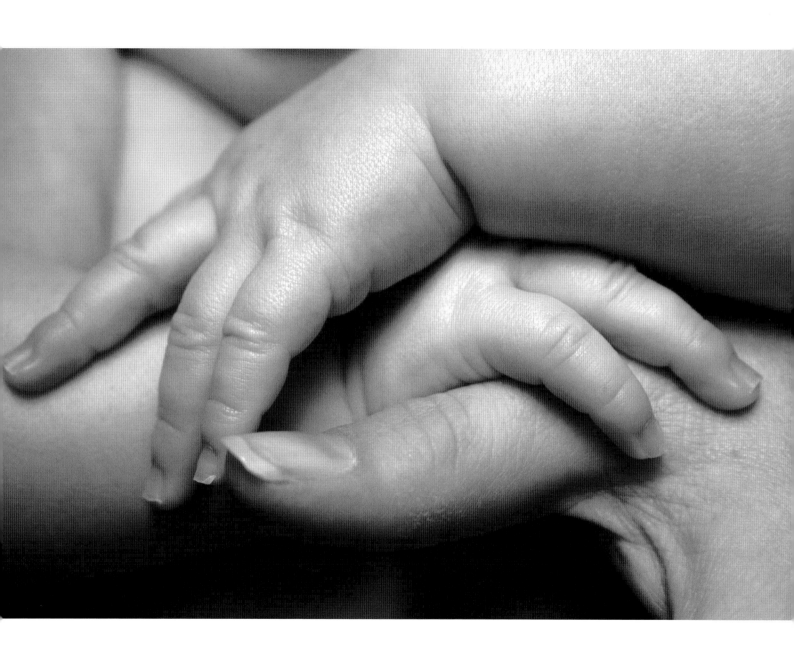

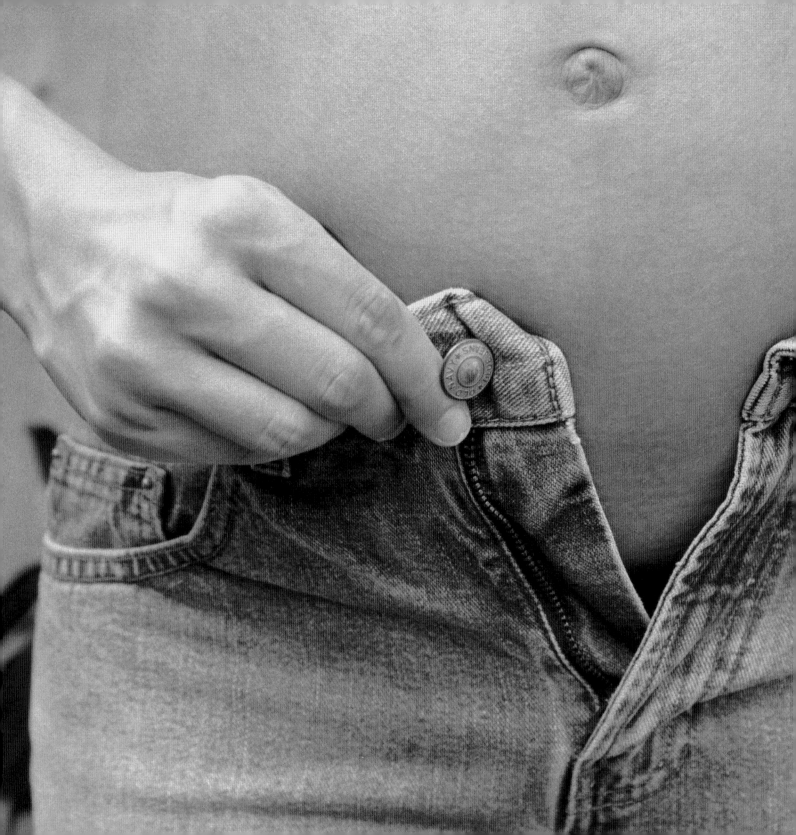

The "sting" of birth is the law
of impermanence (post-partum
depression). To create is to be
in a constant state of accepting
new conditions, new contracts,
new realities and of RELEASING
THE CREATION INTO ITS
OWN UNIQUE EXPERIENCES.

Birth, like the double helix, IS THE SYMBOL AND ESSENCE of the genetic code and life's transference.

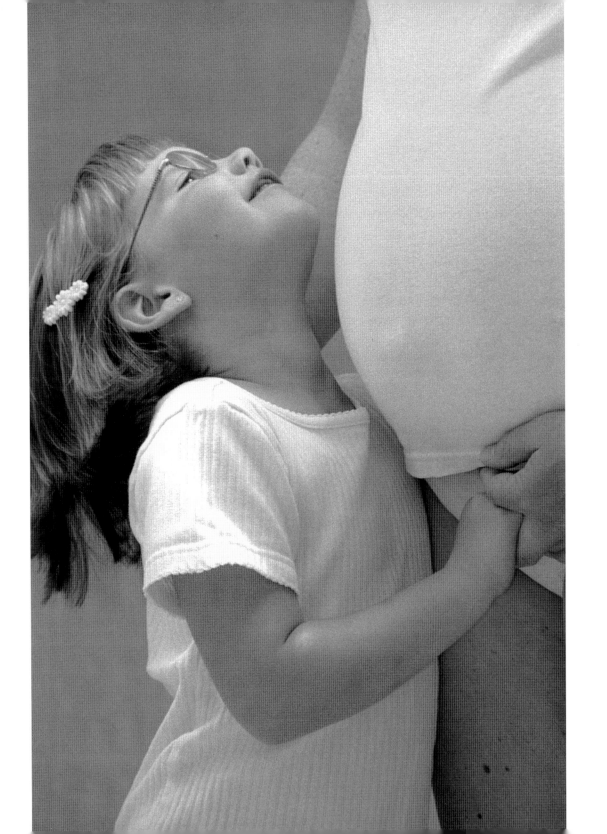

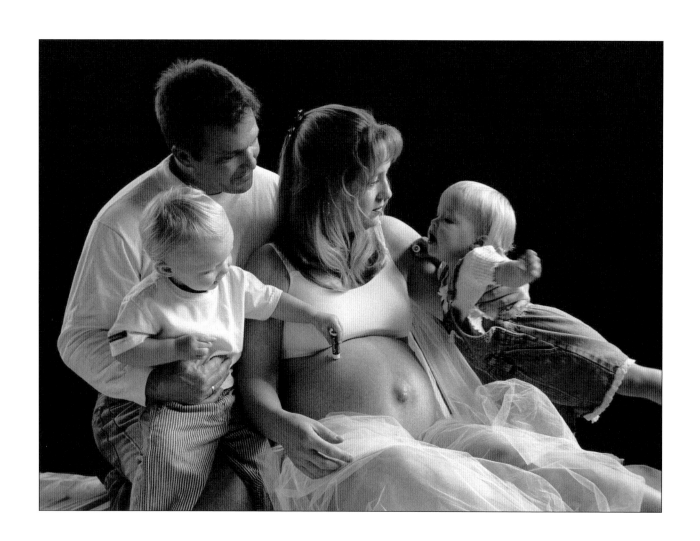

spirit

The cutting of the cord and the delivery of the placenta is symbolic of the parents' need to let go of their child in order that they, as well as THEIR SHARED CREATION, THE CHILD, CAN CREATE THEIR LIVES ANEW. Thus, the energy for the never-ending spirit of life is regenerated and amplified.

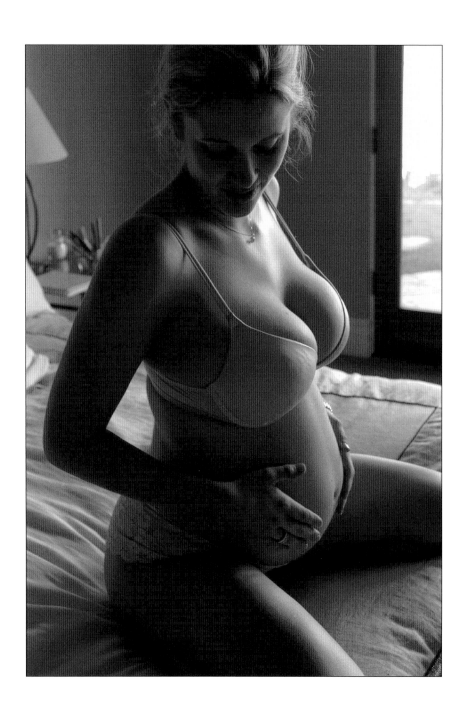

It is difficult to avoid the depression that often accompanies the aftermath of birth. This period marks A NEW BEGINNING following the end of a wish fulfilled.

The surrendering of OUR MOST BELOVED CREATION is a sacrifice, a token of our offering of our trust in life, for life.

Creations are only finalized IN THEIR SHARING.

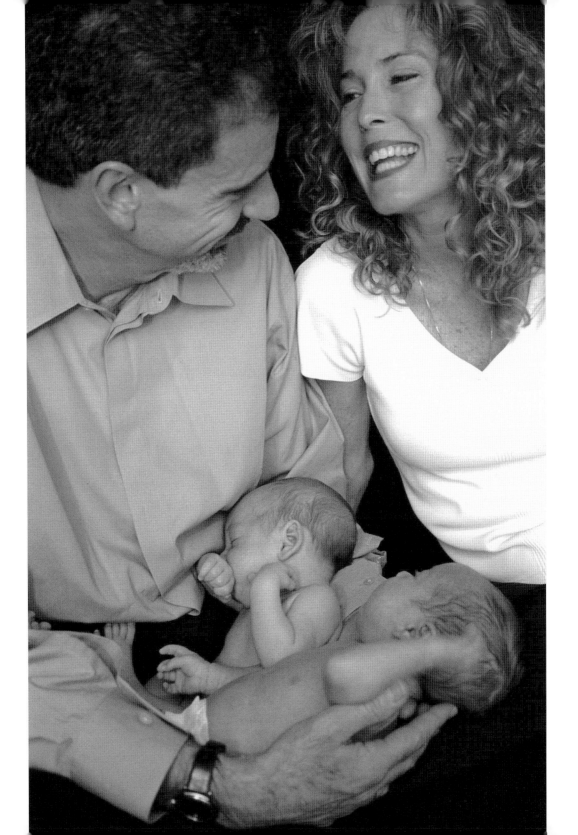

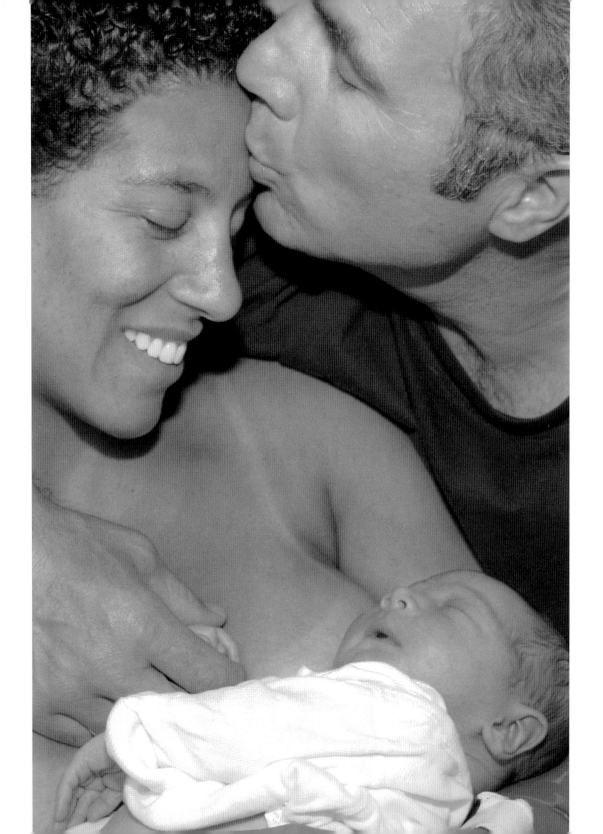

surrender

The void produced by a creation can never be filled by the creation itself, but TO SURRENDER ONE'S CREATION IS TO BE FILLED.

Pregnancy is not truly completed until
the child becomes an active participant,
a co-creator, IN THE COLLECTIVELY
SHARED EXPERIENCE CALLED LIFE.

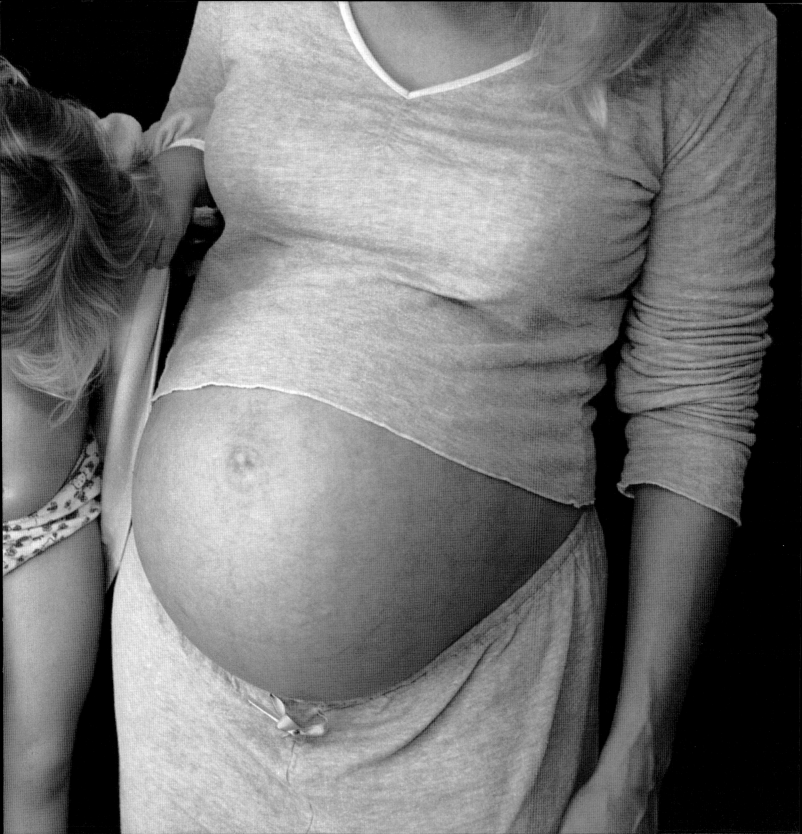

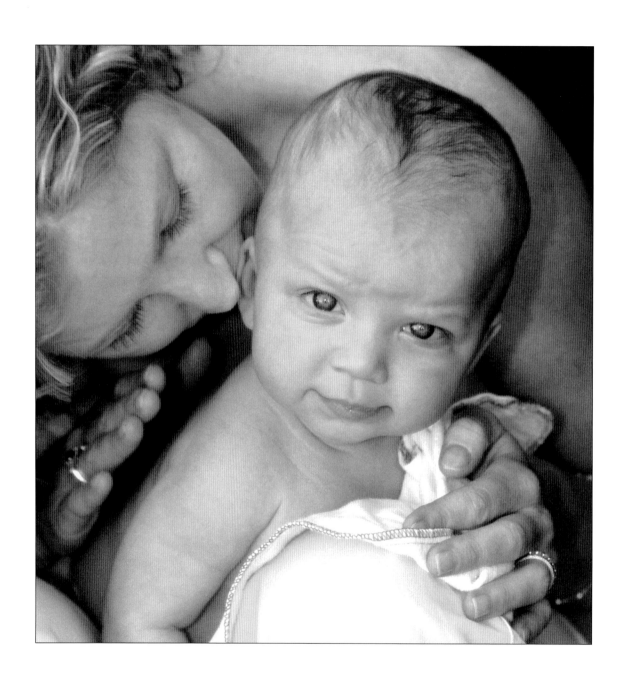

The babe cries: "Why am I here?" Life replies: "TO EXPERIENCE THE EXPERIENCE. Be willing to accept the path of love as well as the path of pain. Each is your teacher. Breathe!" The babe cries: "Why me?" Life answers: "TO ANSWER YOUR OWN QUESTIONS AND TO SHARE YOUR ANSWERS WITH ME. Breathe!"
And then, there is silence—the silence before the first breath.

Each new creation, each new thought, each new belief and action adds to the evolving Universe and to the continuing unfoldment of life,

A SHARED CREATION.

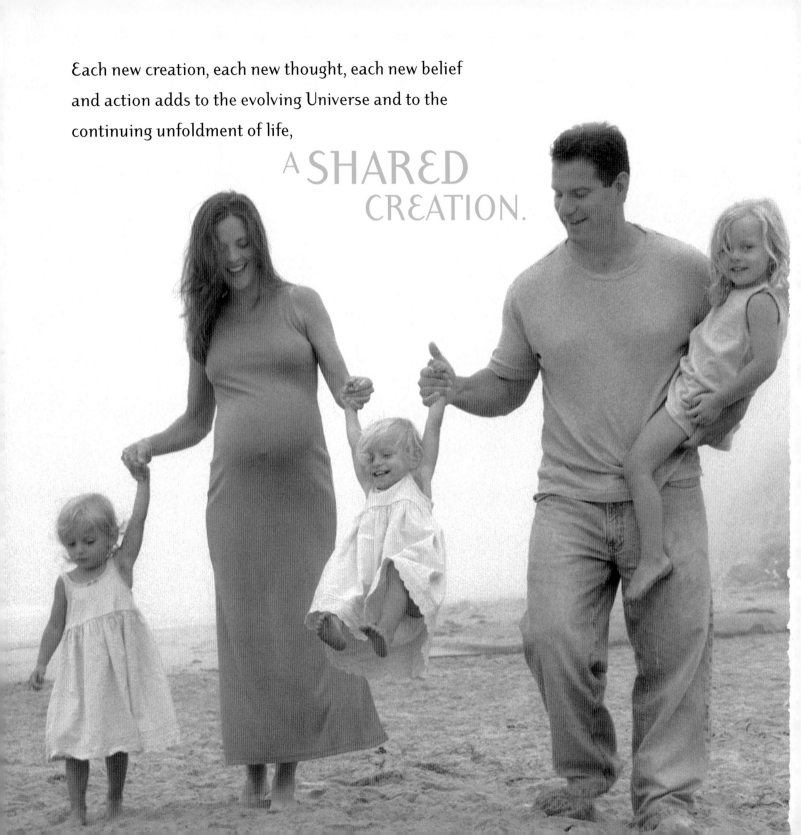